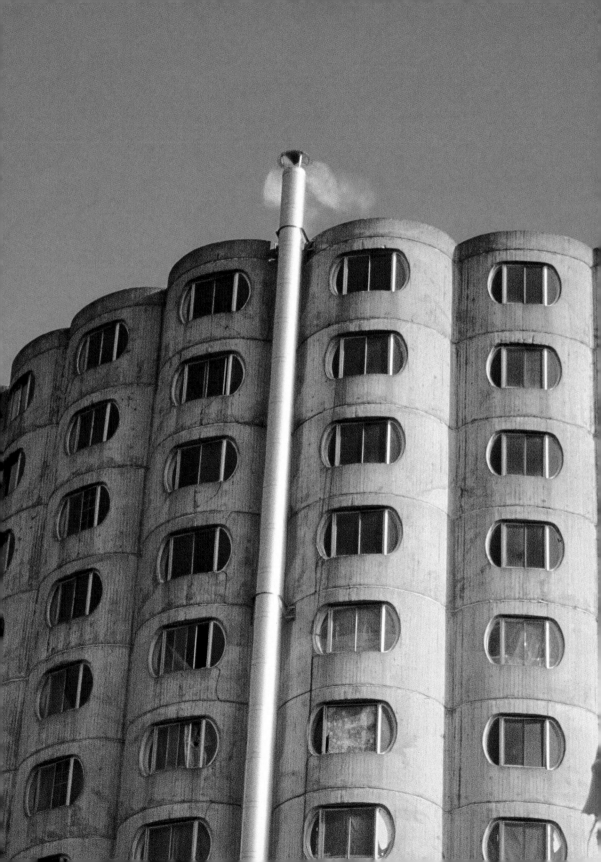

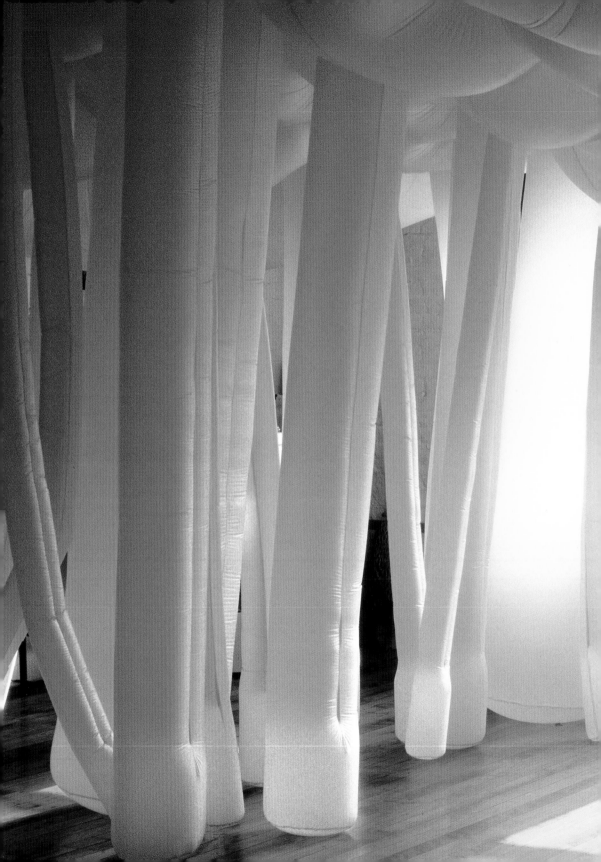

LEE BOROSON

OUTER LIMIT

IAN BERRY

with an essay by ALVA NOË

THE FRANCES YOUNG TANG TEACHING MUSEUM AND ART GALLERY

AT SKIDMORE COLLEGE

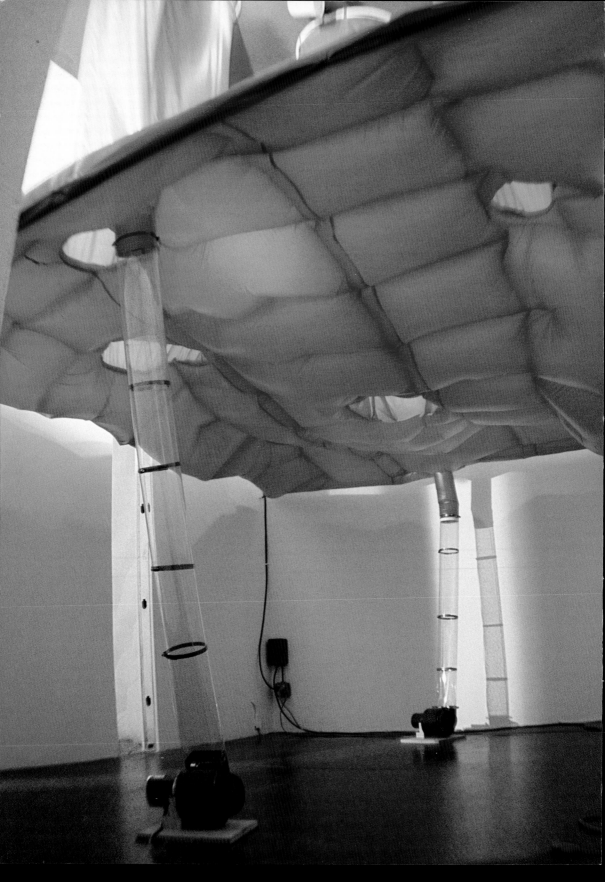

OUTER LIMIT

A Dialogue with L EE B O R O S O N by Ian Berry

Over the past fifteen years, Lee Boroson has been best known for his room-filling inflated sculpture. These often-colorful sewn-nylon enclosures find inspiration in many sources, from historic garden design to the specific architectural details of their sites. Boroson's interest in architecture regularly finds form in descriptions of overlooked sections of buildings. Other works exploit unexpected scale shifts, growing from the microscopic to the macrocosmic, such as his new wall-sized photograph, which attempts to picture the visible night sky with all of its black space removed—a very full image of nothing.

IAN BERRY Can you start by telling me about your earliest sewn works?

LEE BOROSON Sewing has always been part of my work, but I think the first time it became a central element was during the early 1990s when I was reconsidering my studio practice. I felt I was using too many different materials and needed to close things down a bit. So I packed everything away and decided to work with fabric and the basic structure of a bag. Allowing a bag to have multiple compartments and openings, these first pieces were about the potential of what each could hold, as much as its own physical structure. These pieces started out quite simple yet quickly became complex and required that I splay them out on the walls in my studio.

IB Why on the wall rather than on the floor?

LB I started with the idea that they could be clumped on the floor and viewers had to physically deal with the object, but people wouldn't interact with them enough to discover their shapes.

(facing page)
Gum Drop Ceiling, 1997
Nylon, blowers, hardware, vinyl, air
30 x 13 x 16 feet
Installation view, *Emerging Sculptors 10*, Sculpture Center, New York

(previous pages)
Tube, 2002
Nylon, blower, hardware, air
20 x 11 x 18 feet
Installation view, Marie Walsh Sharpe Art Foundation Space Program studio, New York

5

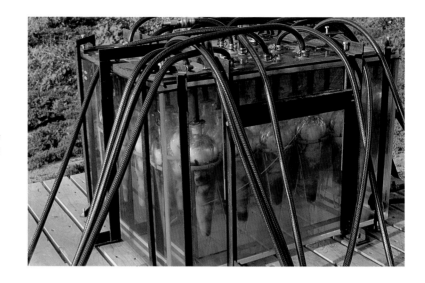

Stream of the Journey
(detail), 1992
Dimensions variable
Shoes, tub, glass, pump,
hose, filters, wood, steel,
spigots, water
Installation view, *Streetsites*
'92, Tijuana River Estuarine
Reserve, California

IB What were the ideas driving these pieces?

LB At that time I was thinking about how clothing relates to iden-
tity and how each piece has a different life, neatly folded in the
store or on the mannequin, and then you add your identity into
the mix. Stories accrue, like "That's my favorite shirt," or "That's
my Sunday best," and then you identify clothes or choose them
based on this personal connection.

IB Was the project ever about your own personal identity?

LB Not outwardly. I was examining how we make that leap from
the anonymous pile of fabric to a specific thing. Some of these
fabric structures were made for holding a particular object, like
Chair, which was a bag with the interior dimensions of my dining
room chair, but most were non-specific. I wanted people to ask:
"What could possibly go in there?"

IB When did you decide to inflate these skins?

LB The direct inflation of the fabric forms came at the point when
the "bags" became so complex that I needed a way to display them

that didn't take away their potential to contain. I liked the idea that it's inflated with air, which is like nothing, and that this is the same air that was over there, and now it's over here. All I have done is contain it.

Actually, I had already been using inflation in my work. My early inflatables were made with rubber bladders that I had manufactured and then covered with Spandex. Previously I used these bladders, filled with liquids, in sculptures about filtration. In other projects I used these forms to describe particular volumes or as objects that could be lodged into the negative spaces of architecture.

IB Architecture is a recurring theme in your work. Was this the first time you started using architecture in your work?

LB I had an interest at an early age but it never developed into a career interest. The burden of a standardized set of rules and the constant negotiating to pursue your ideas seemed overwhelming. The most overt example of dealing with architecture in my daily life happened when I moved to Brooklyn twelve years ago. It was a good survival tactic as a young artist to find the right kind of space and renovate it, so I found myself looking at big empty spaces and reinterpreting these spaces for new functions.

Fake Flake, 1990
Metal cage, handle,
artificial snow
Approximately 16 x 6 x 16"

IB You built your own space?

LB I had to. I wasn't building a house, but I did have to design the space that I was going to work and live in by retrofitting for new functions. What we do in a space is either facilitated or inhibited by what surrounds us. We can make little changes here and there, but in the richest situation, the space around you becomes like an agar, some perfect growth medium for life or your ideas. The idea of architecture as an organic thing felt right to me.

IB Can you describe the installation *Swell* you made in Provincetown in 1994 that literally pushed viewers out of the space?

LB In that piece, air became a medium for the first time. My intention was that you went into an empty gallery, and over a period of time this huge weather balloon inflated, and forced everybody out of the space. Then it quickly deflated and left the space empty again. The architecture could appear to react to viewers.

Later, *Room with a Phew* (1995) was conceived as a solution to some of the issues I had with *Swell*, such as the inability of the balloon to conform to the geometry of the room. *Room with a Phew* was based on the dimensions of the employee break room

at the Munson-Williams-Proctor Institute Museum in Utica, New York. I was having problems getting the shape right in fabric and I realized I needed to put some kind of structure on the inside. From the outside of the form, I began to retrofit an internal set of cables to give shape to this huge fabric room, but I quickly realized the futility of approaching the piece from the exterior. With the piece inflated, I decided to cut a hole in it and design this structure from the inside. I discovered that the interior was a whole other world when I cut it open and walked inside. Suddenly, there was a grand space that I never considered as accessible.

To view this piece you had to take your shoes off, open a zipper, and get inside. I worried that this was too manipulative and I wanted to figure out how to allow people to experience the inside of the piece without having to follow a viewing method —somehow to be able to go inside with out ever leaving the outside. I solved this problem by building the pieces as walls and ceilings rather than objects that you entered—now the viewer could go into spaces enclosed and effected by these odd elements without having to completely leave the surrounding architecture.

IB Is this when you started making sculpture that focused our attention on the real architecture of a given space?

LB In pieces like *Gum Drop Ceiling* (1997) and *Blisterpack* (1997), the intention was to give an experience quite removed from the existing space, yet fully connected to certain aspects of it. The installation would give the viewer sightlines to architectural information. In *Gum Drop Ceiling*, you walked through a long low tunnel in the front gallery, through a slit in the wall, and suddenly you were in a very tall space. This space is bright pink with a low, inflated ceiling. Through viewing tubes in this false ceiling, you

Stuff, 1994
Lycra, rubber bladders, coronets, air
Dimensions variable
Installation view, Long Island University, Brooklyn, New York

9

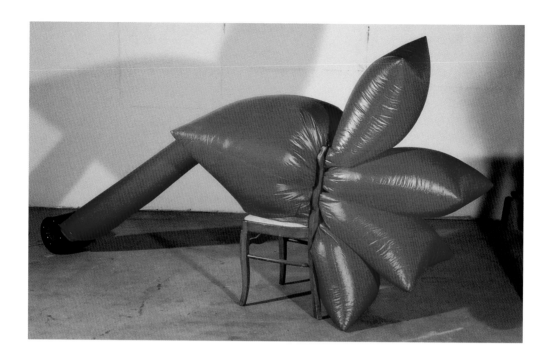

could see the actual ceiling above. Similarly, *Blisterpack* revealed the original ceiling height, which had been truncated in a gallery renovation. A tube in the middle of the sculpture gave you a view of a fixture on the original ceiling. I began to see the artwork as a machine that I could use to focus the experience back onto the architecture.

IB When did you start looking at formal garden designs?

LB I was looking at navigation, especially in the design of Renaissance gardens. When I speak of navigation, I don't mean just how a space is laid out, but how do we find our way through an architectural space and how does that space force us to move through it? What is the experience of the inhabitant moving through a space and how does that experience change as he understands more about the space and has more destinations that motivate his travel? Some spaces are designed to force us to move through towards a particular end—like in a department store when you are directed to the displays...

Tumid, 1995
Ripstop nylon, blower,
chair, air
84 x 48 x 30"

IB ...or a museum, the way we suggest you go to a certain painting.

LB Right. I am concerned with that pathway the viewer is going to follow, and I was looking for a paradigm for the navigation of architecture that wasn't motivated towards a particular end. I considered the garden as a space of contemplation, of self-reflection, or a place where you could go to look at the space you occupy. You are reflecting back on the landscape architecture and for me that became a perfect example of the kind of navigation that I wanted my work to profess—that the viewer would be in the space, navigating the space, to look at the space.

IB Do the pieces like *Hedge* (1999) and *Pleasure Grounds* (1999) relate to specific formal garden designs or are they imagined?

LB Those two projects are based on a generalized idea of structure within formal garden design. *Windowbox* (2000) is a project that remains specific to its source, Villa Lante, an Italian Renaissance garden. Part of my experience visiting that garden was finding myself in a wooded area and realizing that it wasn't the woods, but a planted grid, and then emerging into this beautiful garden comprised of all these *parterres*—low hedges—that were like a maze of geometric patterns. It is also a tiered garden, so as I moved up to a better vantage point, I saw more and more what the whole thing looked like. On the outside of the H&R Block Artspace, the museum where I installed *Windowbox*, there were backlit images of ivy covering the building. As you entered the exhibition the space seemed random and organic, like the woods. This was represented by vertical columns, which in fact were installed as a grid. Then you came upon a low-lying area filled with a network of geometric rooms. Upstairs in the mezzanine you could look over the columns (the trees). From each location you got a different view on the whole project. At each stage, beginning from the outside of the museum, the piece became more transparent and complete. The illusion was revealed in the same way that we understand a complex architectural space when we can grasp the whole layout.

IB You used similar vertical columns in *Slurry* (2001). Can you talk a little bit about how this project came about?

LB I was asked to be in a show called *Thin Skin* about artists who were using air as a central component in their works. The curator approached me to create a work that could act as gateway to the exhibition.

IB Like an entrance or a curtain?

LB Yes, they were thinking of an entrance or gate. I was interested in entries as transitional spaces—lobbies and foyers as extending that sensation of threshold. In the way a revolving door extends the experience of passage, a foyer or entryway can extend it even further. I envisioned a place to decompress from the old climate, leaving the real world and going into this world where everything was inflated. I imagined *Slurry* as a piece that you had to pass through in order to be primed for what was to come.

 I was working on *Slurry* around the time of my first visit to the Tang, and I was immediately attracted to those huge vestibule spaces in the atrium. They are functional as foyers, but there are also bizarre, unusable spaces above them that seem to be only about design. I wanted to build a project for this space that would be framed by the vestibule as though it contained the piece like a giant vitrine.

IB This is literally the skin of the building. One of the purposes of that space is to regulate temperature—so with your piece

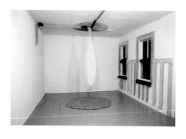 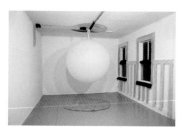 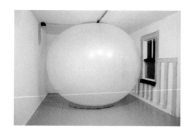

Integument (2004), you are not only bringing our eye up to a part of the building that we normally don't regard but you are also giving us a lesson on what that part of the building does.

LB I started to think about that space as a cross-section because the foyer wasn't designed just to be functional; it also appears to take a slice of the building at that point. In the studio, I was looking at anatomical cross-sections in medical illustrations and remembering an anatomy lab where slices of a body could be viewed from either side. I wanted to bring a connection to the body into this strangely disproportionate element of the museum.

IB Lately, you are relying less on inflatable nylon forms and more on other media. Was there something limiting about the nylon that brought you to other media?

LB I reached a point in my practice where I was expecting the in-flatable form to be able to represent more than it actually could. I needed to move away from it, but I also did not want to lose it completely. Inflatables do some things very well and I have devel-oped a language for using them, but there are preconceptions that the viewer comes to inflatables with. For example: they are fun, they are about balloons and carnivals. That is really not part of it for me. It is much more about utilizing a soft, organic architectural material.

IB Let's talk about *Dewpoint* (2003) as one of the first pieces that moved away from inflatables. How did you find your way to cloud forms?

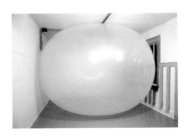 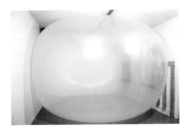

Swell, 1992
Weather balloon, fake fur, vacuum cleaner, pipe, air
10 x 10 x 20 feet
Installation view, Hudson
D. Walker Gallery, Fine Arts
Work Center, Provincetown,
Massachusetts

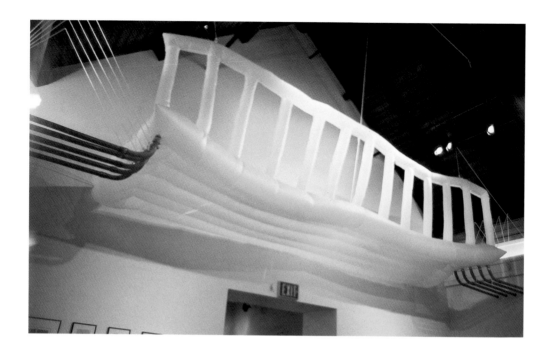

LB I was working on the ceiling with inflatable forms that often look like clouds but also functioned as drop ceilings and was thinking about architecture in general as a "canvas" for activities. Why not approach the cloud cover as a boundary on a larger scale? This is the ceiling of the outdoors, and the clouds appear to be this exquisite modeling material for nature. The challenge is to discuss something so elusive, and to give form to what is just water vapor. It's a miraculous thing that they appear as these structures. I looked into three-dimensional cloud modeling and spoke to some atmospheric researchers to see what was being done in the arena of cloud imaging. Eventually, I decided to work from photo-documentation of orographic cloud formations and to construct *Dewpoint* out of thousands of small blown glass balls that I found in a materials recycling warehouse.

Upper Tier, 1998
Nylon, PVC pipe, rope, air
25 x 6 x 6 feet
Installation view, *Polter-Zeitgeist*, Cape Museum of
Fine Art, Dennis, Massachusetts

IB It is interesting that you use scientific data that we often think of as solid to describe things that are amorphous or theoretical, like a cloud, or like the universe, or like luck. What do you think about looking to science for those answers?

LB I think our culture tends to believe in science as something hard and real, but actually its suppositions are in flux. Theories and ideas are always shifting as we understand new things, and what we thought was true last year, or last week, or last century is not necessarily true anymore. I like that flexibility.

IB One of the things that connects a lot of your recent work is that you are describing things that are bound up in fantasy— like the castle, or making a wish on a star, or things unexplained, like the vastness of the universe or transcendence. Do you feel like you are using your sculpture to address some of these big ideas?

LB Yes, I am looking at ways that we use to structure our surroundings, to provide answers. Architecture and science give order to our surroundings, holding the world together while we move through it. I've mentioned parameters, or the lenses we see things through, and how these constantly changing guidelines affect what is actually seen. This work comes out of an examination of those filters of perception.

Hedge, 1999
Steel, windscreen
50 x 6 x 30 feet
Installation view, *Neuberger Biennial*, Neuberger Museum of Art, State University of New York at Purchase, Purchase, New York

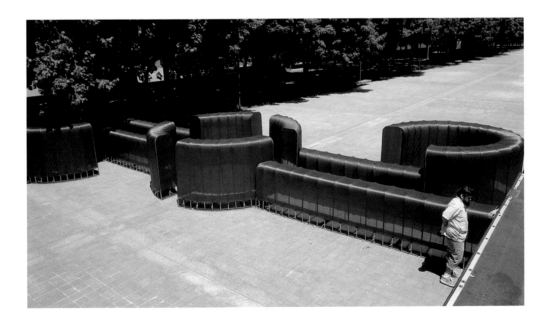

IB *Lucky Storm* (2004) utilizes some overt references to Hudson River School landscape painting. Some of these nineteenth century works are filled with angels, rainbows, and ruins that aren't really in the landscape but function as symbols.

LB Thomas Cole, for instance, would paint from a landscape and then he would return to the studio and re-process the images to present his allegorical narrative—to tell his story. I see a connection between this kind of freedom to take from nature and alter it and the way that architecture filters and delivers nature, functioning like a valve to let it in a little bit at a time. In a formal garden, nature is often manipulated to look "natural." Similarly, in Cole's paintings we can see a form of nature that is very manipulated and controlled, yet it is trying to look quite natural. My idea was to begin with imagery from Hudson River School painting and put it into the museum space and embrace this opportunity to insert my own allegory.

IB Can you talk about the rays which figure so prominently in *Lucky Storm*?

LB Crepuscular rays, or "god rays," are often depicted in romantic landscape paintings and religious paintings and sculptures such as Bernini's *The Ecstasy of St. Theresa*. For me, they are also indelibly associated with psychedelic posters and album cover art from the 1970s.

When I first started making rays, I was trying to capture the shapes formed by the gaps between clouds. First I drew two or three "cartoon" clouds and pushed them together. I used the negative space as the ray shape, but discovered this abstract ray was less convincing than one created using an organic shape. So I looked to other sources for these shapes. I've used the lakes of New Haven and the shapes of the parks of the Emerald Necklace around Boston. The less I tried to make them look like clouds the more they looked like rays. This seemed like a great place to let specific

imagery enter into my work. Crepuscular rays are essentially an optical phenomenon, yet they are also seen as some sort of spiritual event. The lucky charms were an obvious step. Luck and superstition may be the new non-denominational spirituality.

IB Are Cole's paintings also where your interest in castles began?

LB There are four paintings in Cole's *Voyage of Life* series: *Childhood, Youth, Manhood* and *Old Age. Youth* has a floating city in the distant sky, which represents the young man's desire and destiny. The city is castle-like and appears as though it was dreamt by the innocent youth. This destination is presented as a possibility of hope. Everything that you desire is going to be there and you carry that with you into life. These ideas from childhood get passed on culturally, yet they may not pan out when you arrive.

While reflecting on the Cole castle, I began thinking about the "McMansion" and the societal desire to live in a building that presents a façade of wealth and success. What are the stylistic elements that are appropriate for this display of status? Well, certainly in the châteaus of the Loire Valley in France, castle-like elements are a staple, but there are many vernacular forms of architecture that would not be consistent with this logic.

IB Is that the key to the dark side of your rambling castle?

LB Partly. In the film, *Citizen Kane*, the Hearst character builds this crazy palace which quickly becomes a prison, and it seems obvious that a castle was probably not a very comfortable place to live. The Loire valley châteaus were an extension of royalty into aristocracy. These traditions developed from the protective armament of the older castle form. *Outer Limit* (2005), my "McCastle," evolves from these ideas. I tried to distill the essential stylistic details that say "castle" and use those to develop an unfolding structure that houses a lifetime's activities, where the inhabitant might never have to return to the same room twice.

IB As you were making these small-scale, somewhat playful models of big, dark architectures, you were also working on an image of the entire night sky, line by line and for months at a time, on a computer. Is playing with scale shift the connection between those two works?

LB I am attracted to the idea that really big things and really small things look quite similar. In representing the universe there is a necessary reduction of scale. *Outer Limit* deals with scale in relation to your body. Like an architectural model, you walk around it and can imagine yourself inside. *Star Swarm* (2005) is almost like a cartoon; those celestial objects are so big and so far away and they are reduced to dots of color, which are the real images of the stellar bodies. This photographic representation shows these stars and galaxies exactly as they look, but you can't put yourself in it. The scale shift is too great. Those little, tiny galaxies appear to be the same size as just one star, but each contains billions of stars. All of the stars are within our own galaxy, yet most of our galaxy is excluded from the image. The scale is unfathomable. I estimate that there are approximately 12 million objects compressed into *Star Swarm*. It becomes a way of looking at the whole, yet it is not a reduction. Some things that are unseen are revealed and others removed, exposing a system or theory that we rely on to understand what we do see.

IB Is that what all of your sculpture is about in some way?

LB Perhaps. We look at the universe very differently if we believe it is finite as opposed to infinite. These "truths" that we choose to accept shape the lens through which we see the world.

IB How exactly did you build this huge photograph?

LB I first conceived of the star project while considering how to make a photograph of nothing. I quickly realized that the elusive occupation of trying to capture "nothing" would likely produce dull results. In the development of the idea I decided if I could

remove the emptiness from the universe it might begin to talk about the power of "nothing". My intention was to collapse images of the entire visible universe into one massive image. I began with data (images) downloaded from the Sloan Digital Sky Survey. With the help of my brother, Todd Boroson, who is an astrophysicist at the National Optical Astronomy Observatory, I designed software that enabled me to remove the black background—the empty space—from these images. The program locates the celestial bodies—stars, galaxies, and asteroids—and moves them to form a central cluster on a new image. This celestial ball grows until it contains all visible matter in the downloaded images, creating an absurd visual representation of a large portion of the universe, recollapsed to its "original" massive form. Though the true location of the original objects within the universe is obliterated, they all remain in the same essential relationship with each other in the condensed image. The final image of *Star Swarm* is a 12 x 12 foot photograph, which represents approximately 5% of the celestial sphere, and is printed using digital c-print technology on 72-inch wide color photo paper.

IB When you start a project, do you start with a question, or do you start with constraints and then ask questions about those constraints?

LB I do both. Sometimes constraints, like a specific site, inspire a solution. This can be a great situation, because as a sculptor it becomes clear how I need to proceed and what I want to make to best utilize the opportunity. Other times, constraints can be a hindrance and a burden. I've had times when I don't find clarity about a particular project for many months. This doesn't mean that ultimately it won't be a good piece, but it is nice to have a strong image from the beginning about what a project needs to be. Usually I am starting with a specific idea, but often it changes in the process and hopefully becomes richer as an artwork. *Star Swarm* is a good example, because I began by trying to achieve one aim and ended up on a completely different end of the spectrum— achieving results I would never have initially imagined.

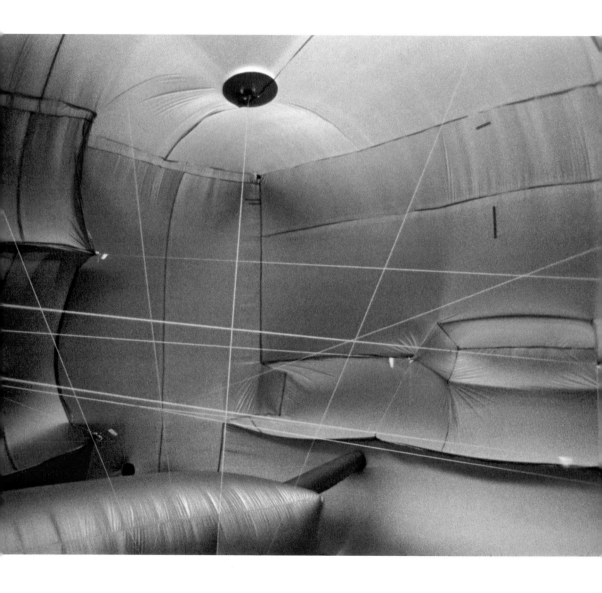

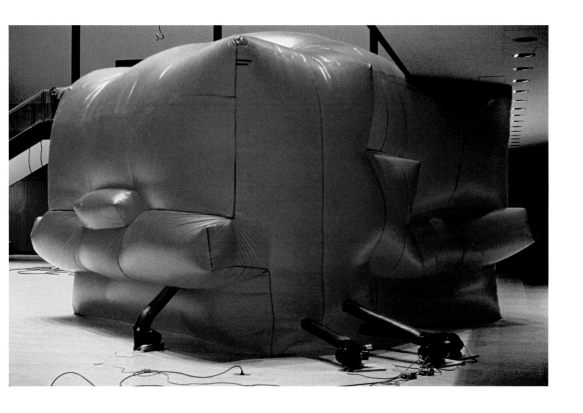

(this page, detail facing)
Room with a Phew, 1995
Nylon, blowers, twine, vinyl, zipper, air
15 x 12 x 15 feet
Installation view, *Sculpture Space 25th*
Anniversary Exhibition, Munson-Williams-Proctor
Art Institute, Utica, New York

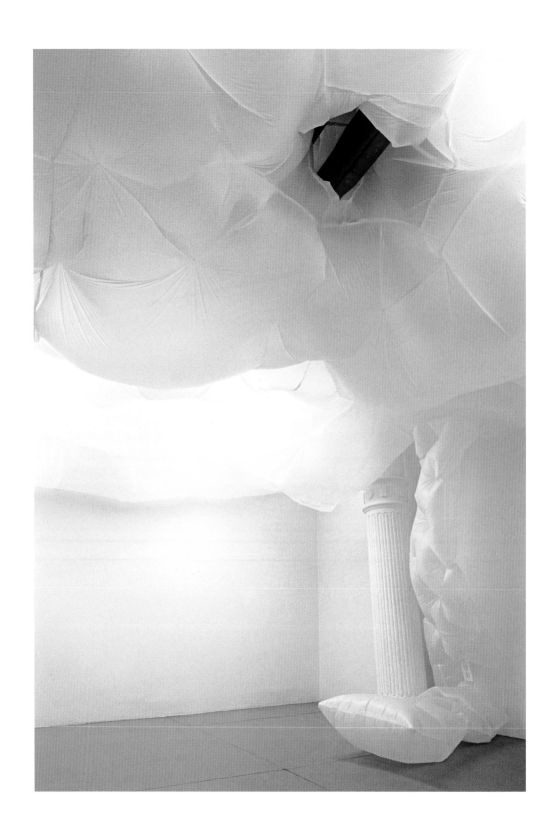

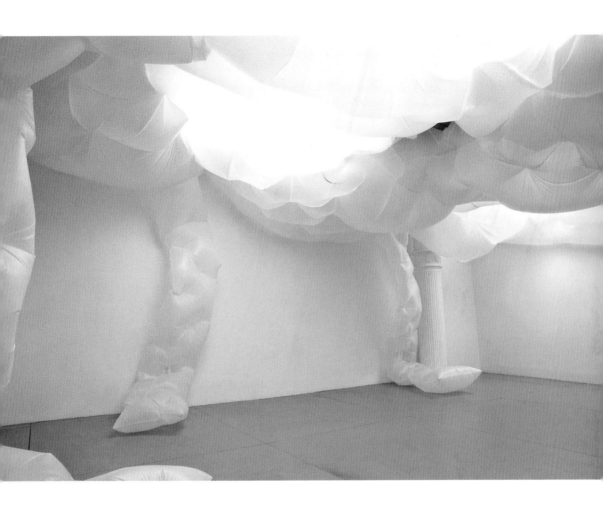

Blister Pack, 1997
Nylon, electrical components,
lights, blower, air
20 x 16 x 28 feet
Installation view, Bravin Post Lee
Gallery, New York

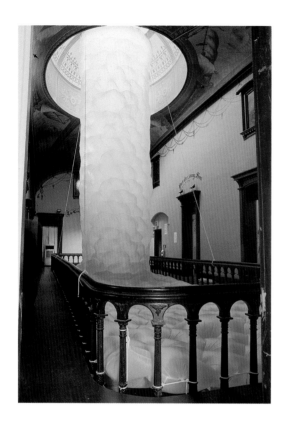
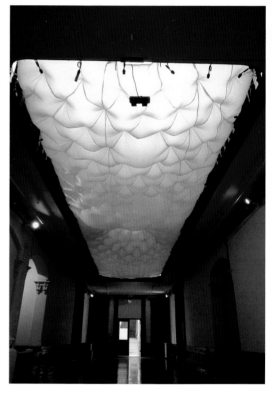

(this page and facing)
Whitewater, 1997
Nylon, blower, webbing, rope, pulleys, air
65 x 55 x 20 feet
Installation view, Newhouse Center for
Contemporary Art, Snug Harbor Cultural
Center, Staten Island, New York

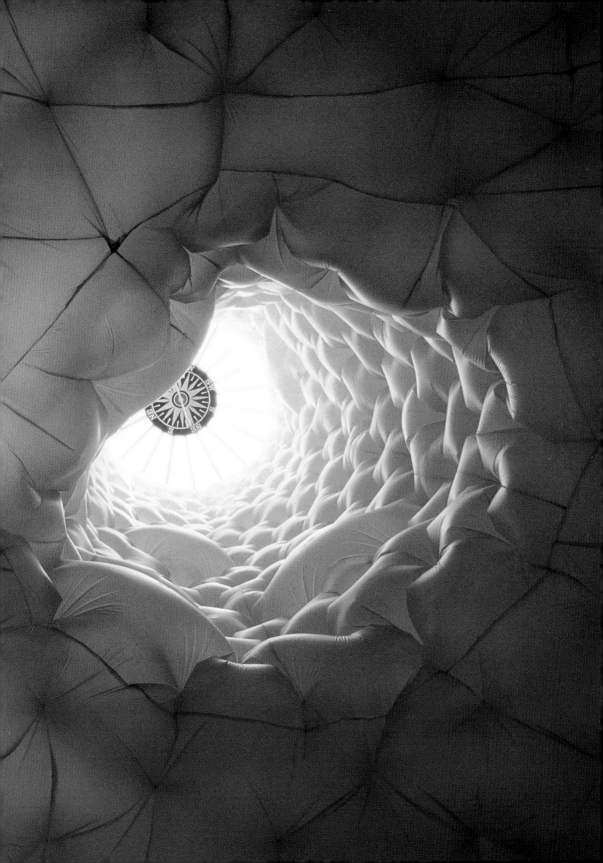

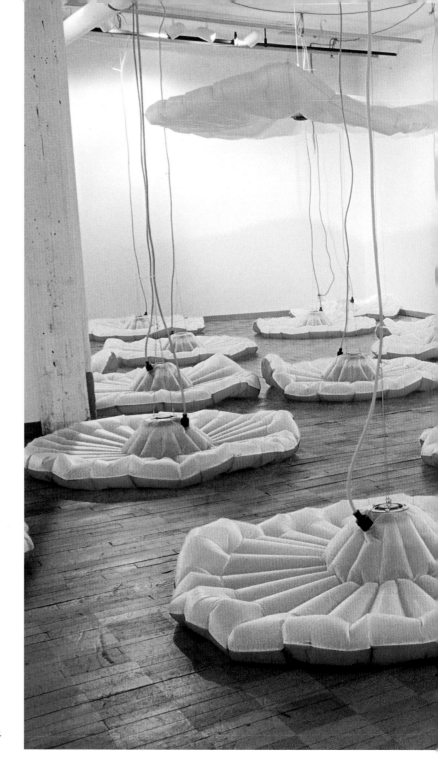

Pleasure Grounds, 1999
Nylon, blowers, electrical
hardware, rope, air
Dimensions variable
Installation view,
Genovese/Sullivan Gallery,
Boston, Massachusetts

26

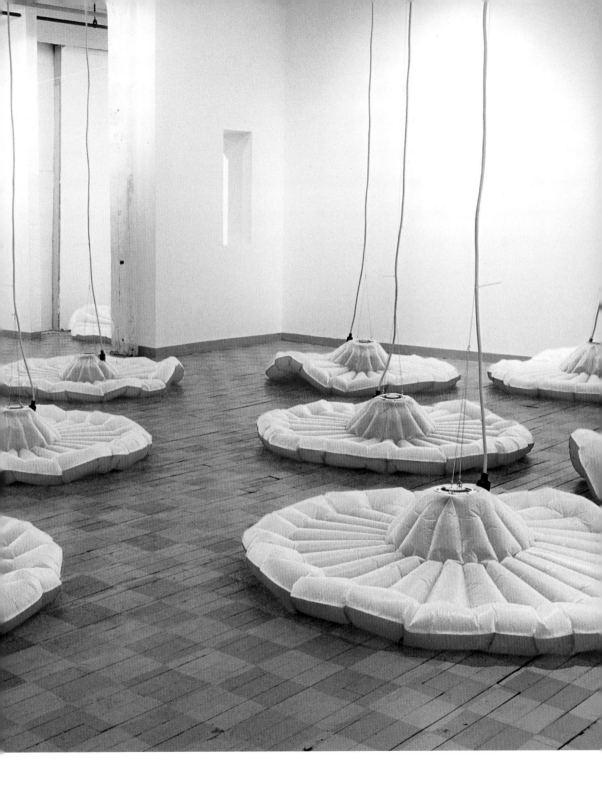

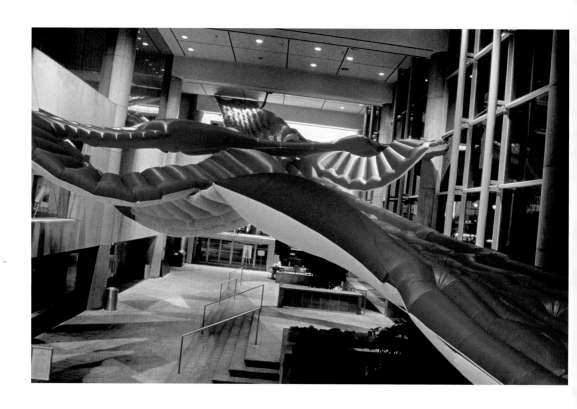

(this page and facing)
Underpass, 2000
Nylon, cable, blower, air
120 x 50 x 50 feet
Installation view, Whitney Museum of
American Art at Philip Morris, New York

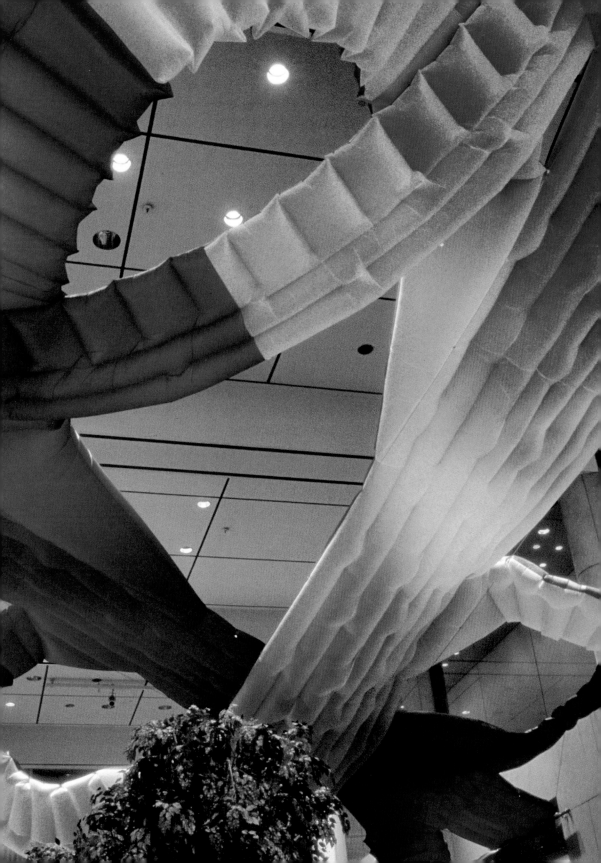

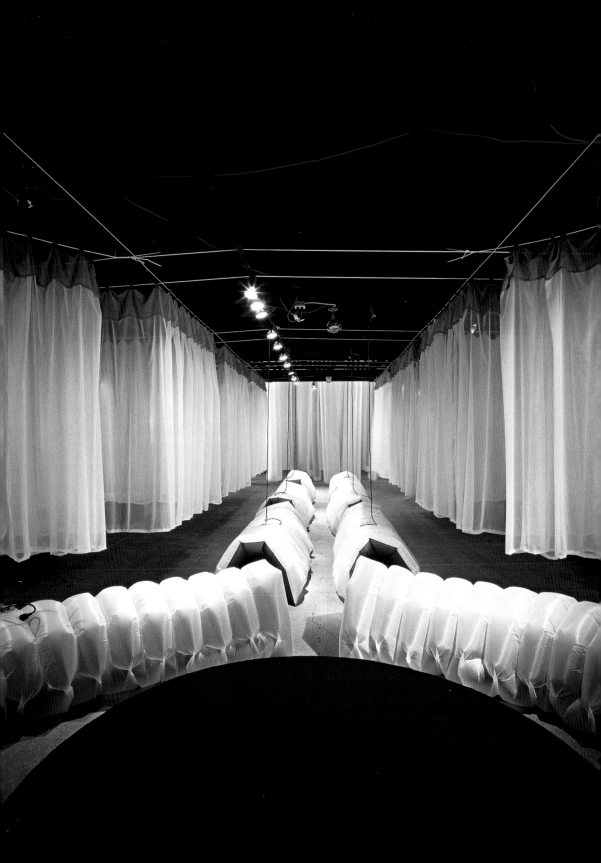

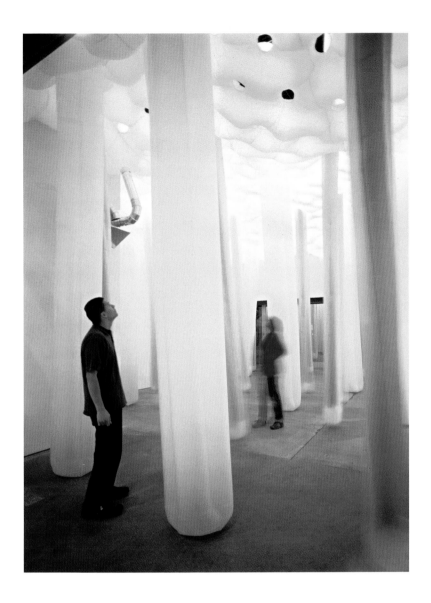

(this page and facing)
Windowbox, 2000
Nylon, sheet metal duct, rope, geor-
gette, foam, polar fleece, blowers,
hardware, photos on backlit vinyl, air
Dimensions variable
Installation view, H&R Block
Artspace, Kansas City Art Institute,
Kansas City, Missouri

(overleaf)
Slurry, 2001
Nylon, blowers, chain, air
Dimensions variable

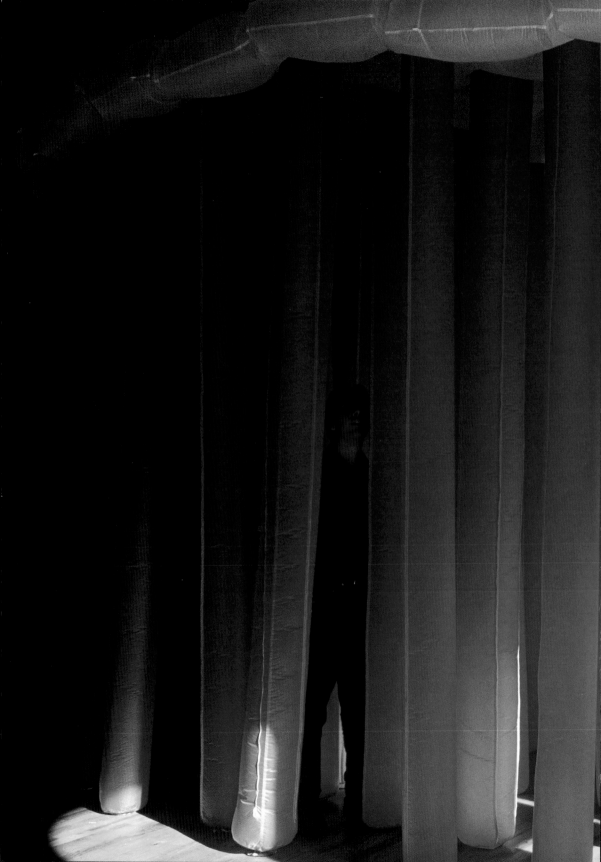

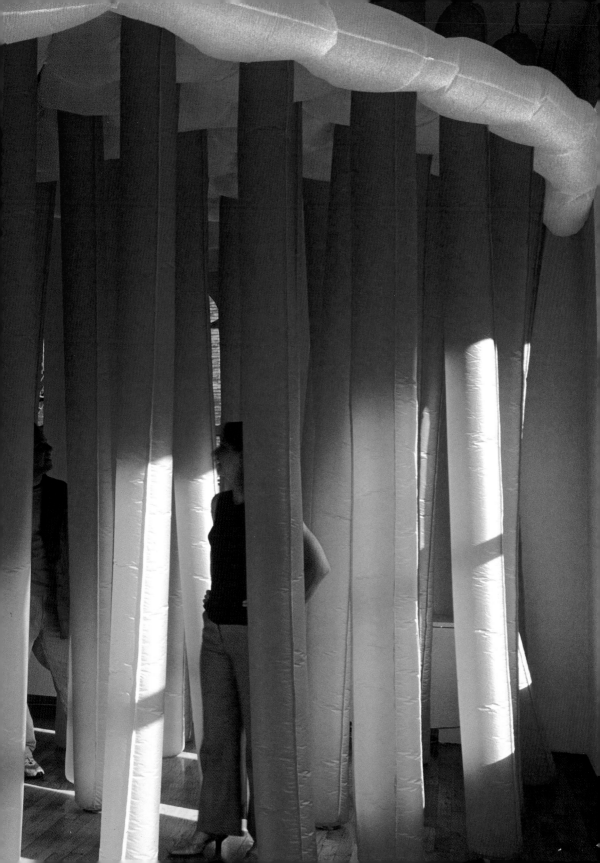

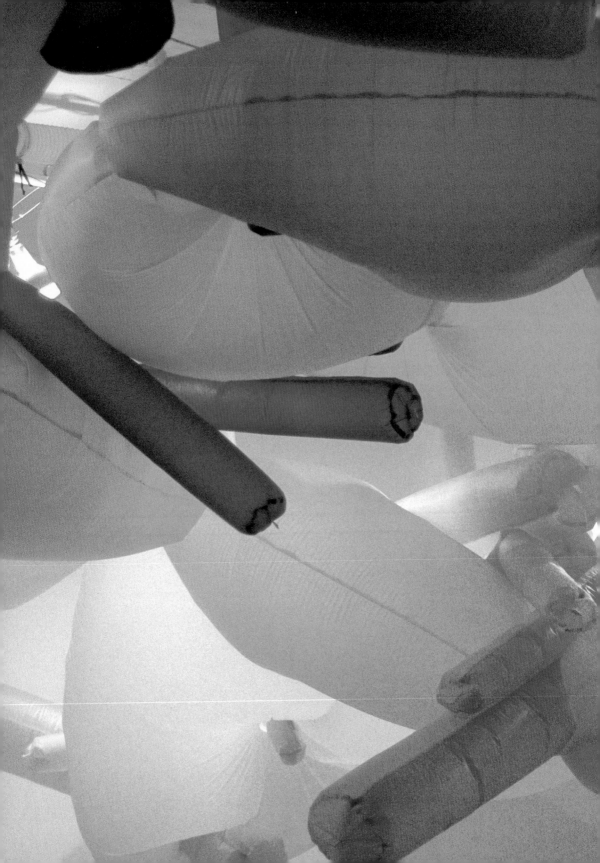

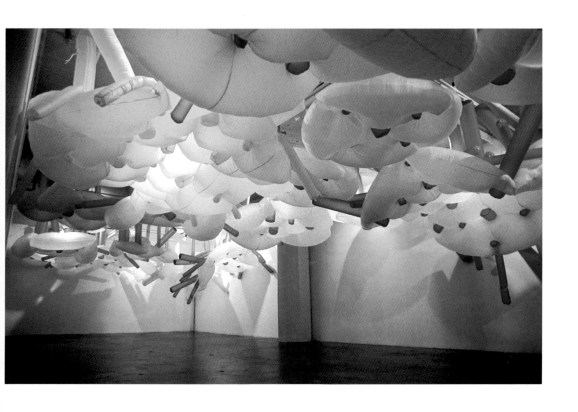

Lake Effect, 2002
Nylon, blowers, tubing, air
65 x 11 x 25 feet
Installation view, Hallwalls Contemporary
Art Center, Buffalo, New York

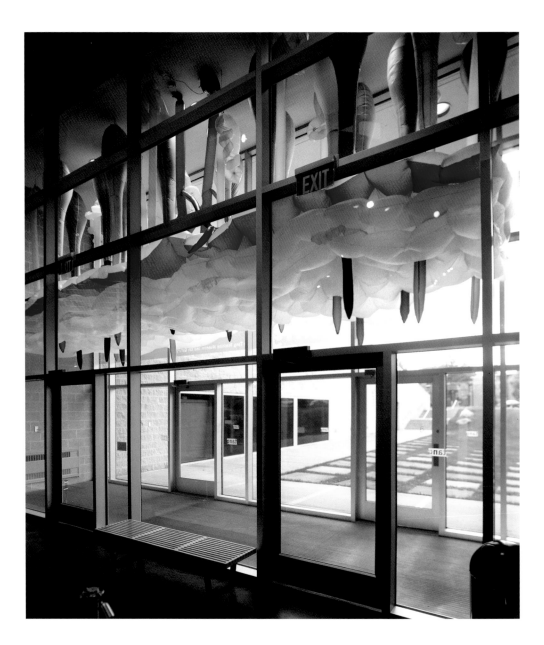

(this page and facing)
Integument, 2004
Nylon, blower, air, hardware
30 x 12 x 8 feet
Installation view, Tang Museum, Skidmore
College, 2004

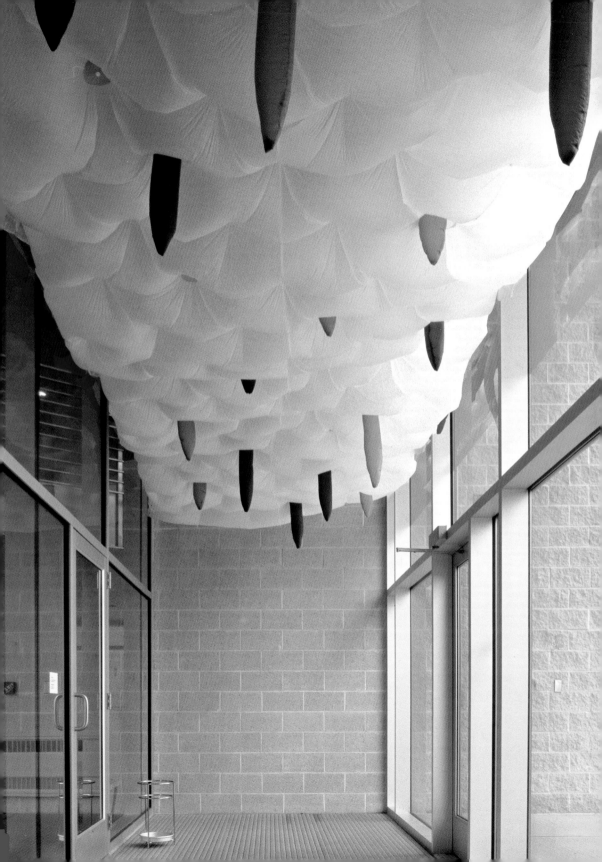

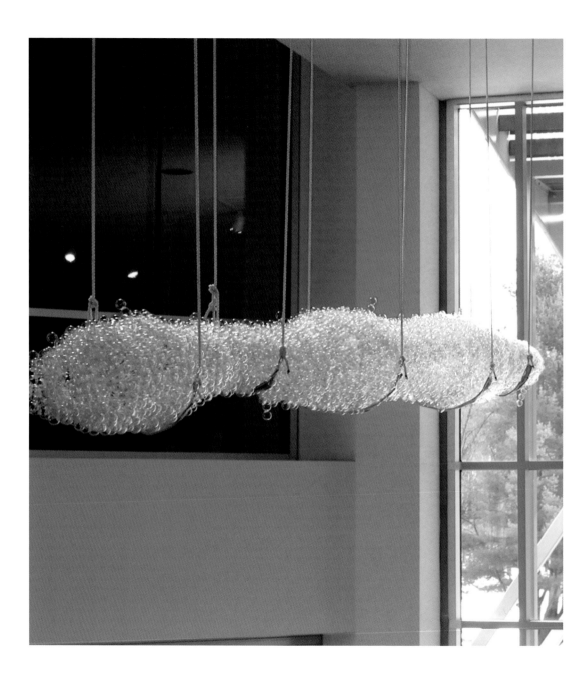

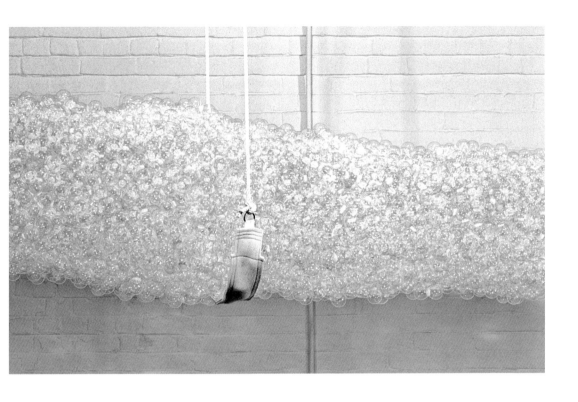

Dewpoint, 2003
Glass, silicone, felt, wood, rope, hardware
19 x 22 x 120 inches
This page: installation view, Genovese/
Sullivan Gallery, Boston, Massachusetts
Facing page: installation view,
Tang Museum, Skidmore College

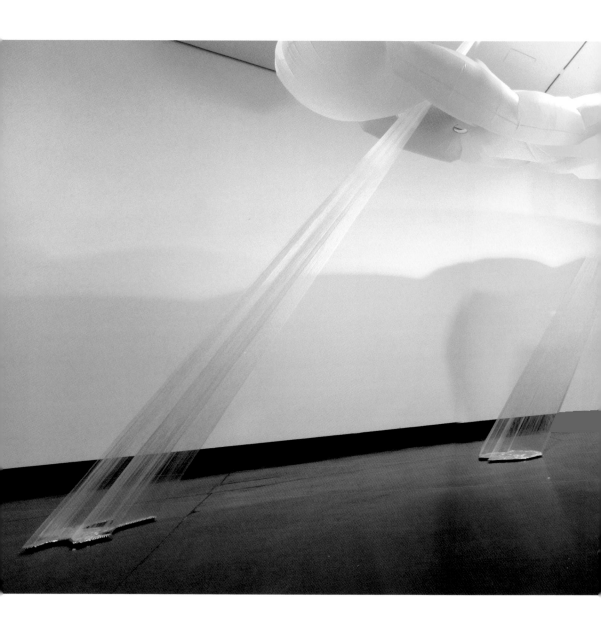

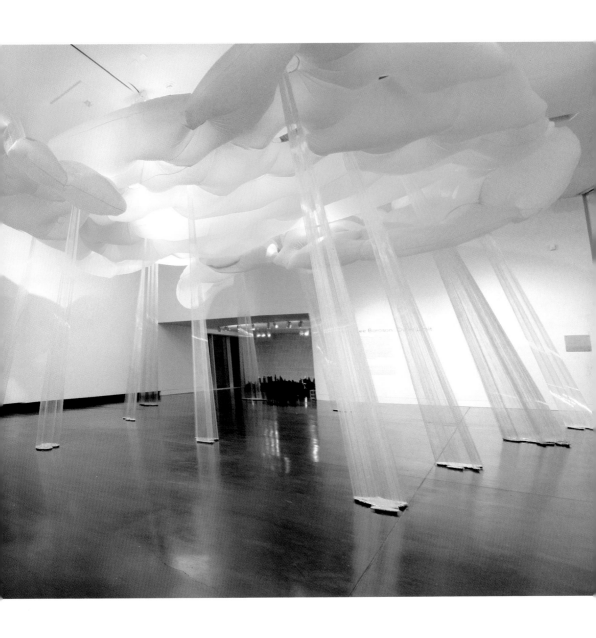

Lucky Storm (2), 2005
Nylon, monofilament, stainless steel,
hardware, blower, gold, air
Dimensions variable
Installation view, Tang Museum,
Skidmore College, 2005

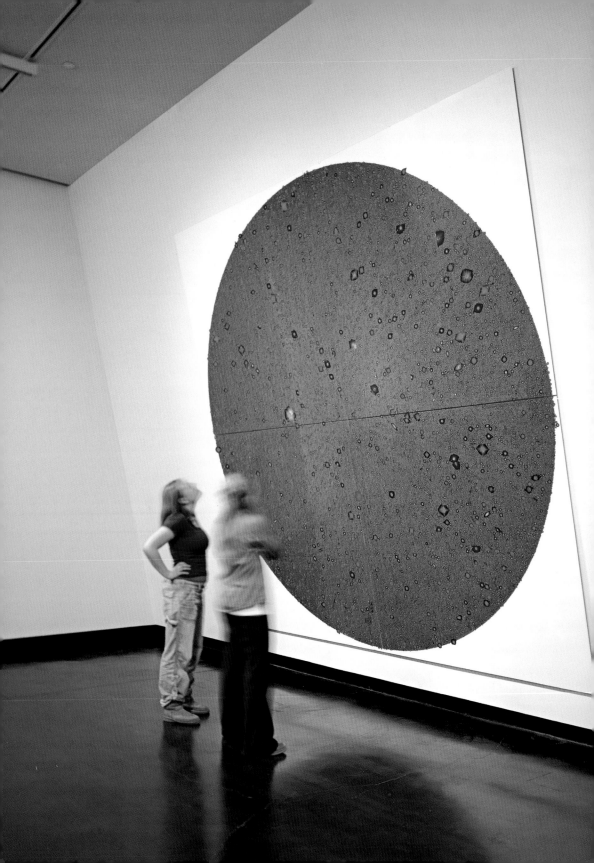

EXPERIENCE AND ITS OBJECTS

by Alva Noë

Perception reveals the world to us and makes it available for thought and for science. What is the difference between the way the world enters into experience, on the one hand, and thought and science, on the other? This is a problem for philosophy. It is one that art can help us answer. Consider:

Do you see the stars? They are so far away that they may have flickered out of existence long before their light reaches you. It might be better to say that you see lights in the sky and judge them to be *star light*. This is why the fact that the stars appear as points of light in the night sky doesn't force us to believe that stars actually resemble points of light. Stars are no more like points of light than people are like ants when they are seen from a great height.

A scientist is likely to demur. The scientist says your relation to the things you see is never more direct than your relation to the stars in the night sky. Perception is a delicate causal process wherein light is reflected off objects in such a way as to give rise to the neural events on which conscious experience finally depends. A remote signal reaches your sensory periphery at the speed of light and then travels at much slower speeds as it propagates in the nervous system. It is no more possible to experience an event when it actually happens than it is to receive a letter before it is sent. We live in the past. Events in the world outpace the experience, which is their result. It would be prejudice to think that the time it takes for light to reach you has any bearing on whether, when you receive such light, you see.

In fact—so says the scientist—your relation to a coin is *exactly like* your relation to stars. A star looks from here misleadingly like a point of light. But the coin, held up before you at an angle, looks from here misleadingly like an ellipse. You do not perceive the coin itself, for what you perceive is ellipsoid, but the coin is circular. What you see is ellipsoid; you *infer* the circularity of the object

(facing page)
Celestial Incorporation Project:
Star Swarm, 2005
12 x 12 feet
Lightjet C-print
Installation view, Tang Museum,
Skidmore College, 2005

43

whose projection is thus made available to you. This is true also with stars, with coins, and with all other sublunary objects. Perceiving, according to the scientist, is like astronomy; it is a theoretical activity of drawing inferences, however unconscious, as to the far-away causes (e.g. stars, people, circular coins) of stimuli close to home (e.g. points of light, ant-like blips, elliptical profiles).

Undergraduates, like readers of newspapers, *love* to be told that things are not as they seem. We get a certain *frisson* when our attitudes—about the common cold, about sex, about diet and health—are *unmasked* by the cool hand of science. This tendency partly explains our willingness to entertain what is surely an outrageous suggestion that all seeing is like seeing stars. Is it possible to resist this idea? Yes. Consider: the scientist's argument takes for granted a particular conception of the nature of perceptual experience. To begin to zero in on this conception, recall the causal story. Vision is a three-stage process; first, objects affect incident light; second, light irradiates our sensory receptors (the retina); third, the activation of the sensory receptors produces electrochemical activity, which results in *conscious experience*. Physics and neuroscience occupy themselves with stages one and two. As for the third and final stage—when physical processes in the brain give rise to subjective states of consciousness—there is no accepted framework for investigation. The only consensus is on this one point: no one knows how the action of the brain gives rise to consciousness. No one even has a good *story* about how this is supposed to go.

Given this, it is remarkable that scientists, and many philosophers, tend to assume that perceptual experiences are *optical projections* or *representations*. If you think of experiences that way—as projections or images of a distal world on an internal screen—then you can hardly insist that there is a principled difference between the way the coin, on the one hand, and the stars, on the other, affect consciousness. Just as a round coin may look elliptical from here, so stars may look like points of light. Perceiving is mediated by this kind of projective relation.

We can grant that how things look depends on your perspective—how could we challenge that—without granting the problematic

projective conception of experience? Importantly, there is nothing in settled science that forces this conception on us. In my view, the assumption is optional and can be rejected. Here is an alternative conception, one no less consistent with the empirical facts about perception as a physical process. Let our paradigm of perceiving be *active touching*. Consider a blind person's experience of the texture of the sidewalk as he or she tap-taps along with a cane. He or she experiences the sidewalk and its texture, but not by forming a picture of it, in the head, as it were. The experience, rather, is the temporally extended activity of probing, one that is constituted not only by what the perceiver does, but by the way the world resists or even acts back. Whereas on the conception I challenge— which is not only our imagined scientist's conception, but also that of the tradition that comes down to us from Descartes—experiences are self-standing and internal, on the alternative way of thinking of perceptual experience, experience is not something that takes place within us, but something we do.

If this alternative conception is right, then experience should not be thought of as a way in which we represent things, as it were, in our consciousness. Rather, it should be thought of as a way in which we make contact with things. Perceptions aren't *about* the world; *they are moments of contact with the world.* On the alternative conception, experience is a dynamic episode of engagement with the world. The world enters into experience the way music enters a dance, or, to use a better metaphor, the way the terrain guides us when we walk. The object, in perception, shouldn't be thought of as a theoretical posit, but as *terra firma.* We encounter it. The science of consciousness investigates, or ought to investigate, the way we manage to attain and preserve this kind of contact with the earth. The brain plays a big role in this story, but it can't be the whole the story. The brain, the body, and the world, work together to make consciousness happen.

Back to the stars. Against the background of the alternative conception, we can appreciate that it is not so unreasonable after all to suppose that when we look up at the night sky, we do not succeed in making contact with the stars. The stars are just too far away!

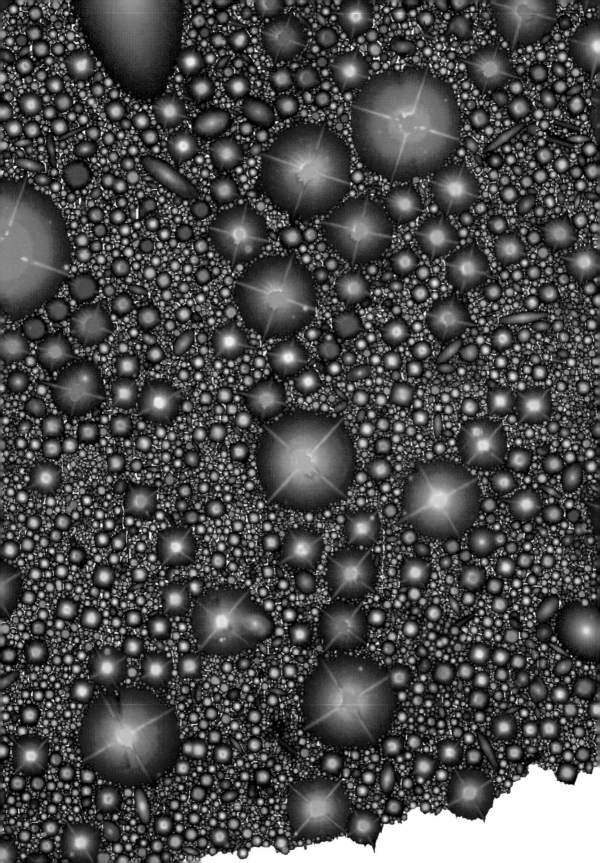

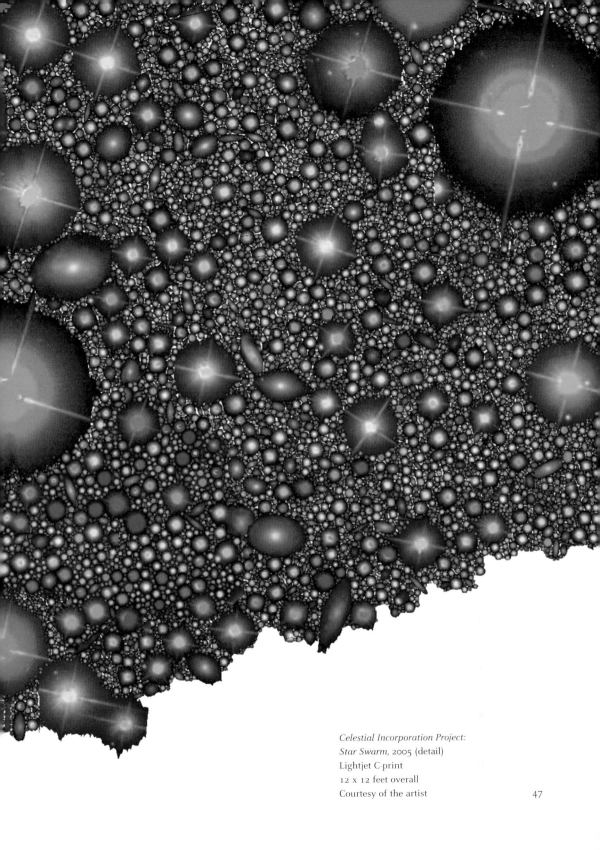

Celestial Incorporation Project:
Star Swarm, 2005 (detail)
Lightjet C-print
12 x 12 feet overall
Courtesy of the artist 47

We do manage to make contact with the lights. If *they* were to disappear, it would make a difference to how things look. And so with the coin: skillful perceivers do manage to connect to the coin when they take in its elliptical appearance. Circular coins look elliptical from an angle, after all. If you move the coin far enough away, it ceases to look circular, or elliptical, and becomes little more than a spot. This reveals not that coins seen from such and such a distance look like spots, but rather, that at such and such a distance, one's ability to see the coin—to maintain contact with it—breaks down.

This puzzle about what we see is interesting for a few different reasons. It is a puzzle precisely about *what we see.* The puzzle doesn't concern the nature of stars or our relation to them or the projective properties of coins. It concerns, rather, the question whether we conceive of our selves as seeing *them*, as opposed to mere appearances of them, when we "experience coins and stars." What is the face value of our experience? It is remarkable that this can be an open question. And at least part of what makes this so remarkable is the fact that it is entirely unclear what methods we should use to try to settle it. Crucially, science is no help to us.

What about art? Can it help us understand the way objects *enter into* our experience of the world? One way it could do this is by making experience itself its subject matter. Another way art can do this is by making *science* and the *ways of representing the world in models and in thought* its subject matter. Scientists model, and models capture structure, offer explanation, and enable prediction. Some artists *play* with models, by warping them, and so cast light on the way modeling reveals the world, and on the differences in the way science and experience do this.

Lee Boroson's *Celestial Incorporation Project* illustrates this. Boroson transforms high-resolution digital images of the sky— images that we *know* represent the stars and their positions— by removing empty spaces between the star-images. In this way Boroson constructs models that have been, at least partially, denuded of their representational powers, for he has disrupted the isomorphism, the rules of projection, which enables such models

to represent. What are the results of these manipulations? In one sense, what results are new models, models that preserve some, but not all, of the spatial relations among the stars. In this connection, it is important to keep in mind that Boroson uses the very same raw data that actual astronomers use—unanalyzed astronomical data gathered by the Sloan Digital Sky Survey. In another sense, however, Boroson's models can be thought of as articulating *questions* about modeling itself and so about the way stars—or any other theoretical entities—enter science. In this way *Celestial Incorporation Project* helps to demarcate the place of science in human experience, by calling attention to the fragility of the theoretical grip we have on such objects. *Celestial Incorporation Project* is a question mark put to science in the face of experience. We encounter the question, in thought, by encountering the work of art, in experience.

The Celestial Incorporation Project was created by Lee Boroson with Todd Boroson with the assistance of the Sloan Digital Sky Survey. Funding for the SDSS and SDSS-II has been provided by the Alfred P. Sloan Foundation, the Participating Institutions, the National Science Foundation, the U.S. Department of Energy, the National Aeronautics and Space Administration, the Japanese Monbukagakusho, the Max Planck Society, and the Higher Education Funding Council for England. The SDSS Web Site is http://www.sdss.org/.

The SDSS is managed by the Astrophysical Research Consortium for the Participating Institutions. The Participating Institutions are the American Museum of Natural History, Astrophysical Institute Potsdam, University of Basel, Cambridge University, Case Western Reserve University, University of Chicago, Drexel University, Fermilab, the Institute for Advanced Study, the Japan Participation Group, Johns Hopkins University, the Joint Institute for Nuclear Astrophysics, the Kavli Institute for Particle Astrophysics and Cosmology, the Korean Scientist Group, the Chinese Academy of Sciences (LAMOST), Los Alamos National Laboratory, the Max-Planck-Institute for Astronomy (MPA), the Max-Planck-Institute for Astrophysics (MPIA), New Mexico State University, Ohio State University, University of Pittsburgh, University of Portsmouth, Princeton University, the United States Naval Observatory, and the University of Washington.

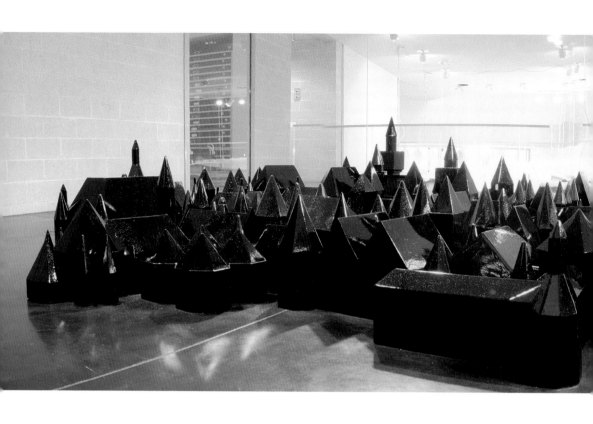

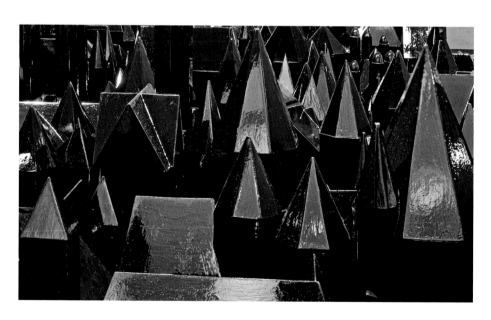

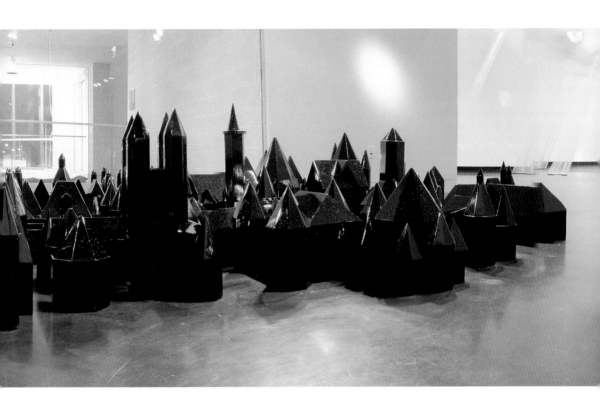

Outer Limit, 2005
Painted MDF
Approximately 40 components,
overall dimensions variable
Installation views, Tang Museum,
Skidmore College, 2005

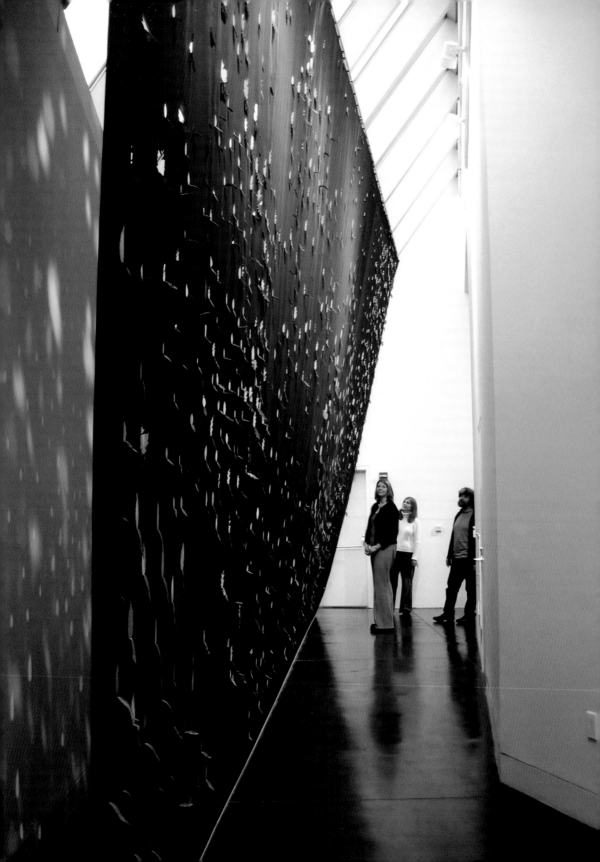

CHECKLIST

All works by Lee Boroson, courtesy of the artist,
Brooklyn, New York, unless otherwise noted

1. *Pleasure Grounds* (4), 1999
Nylon, blowers, hardware, air
Dimensions variable

2. *Trim*, 2005
Embroidery on fabric, zippers, hardware
16 x 45 x 3 ¹/₂ feet

3. *Lucky Storm* (2), 2005
Nylon, blower, stainless steel, monofilament,
hardware, gold, air
Dimensions variable

4. *Dewpoint*, 2003
Glass, silicone, wood, rope, felt
120 x 228 x 22 inches

5. *Integument*, 2004
Nylon, blower, hardware, air
30 x 12 x 8 feet

6. *Outer Limit*, 2005
Painted MDF
Approximately 40 components
overall dimensions variable

7. Lee Boroson with Todd Boroson
*Celestial Incorporation Project:
Star Swarm*, 2005
Lightjet C-print
12 x 12 feet

(facing page and detail at left)
Trim, 2005
Installation view, Tang Museum,
Skidmore College, 2005

LEE BOROSON

Born in Stamford, Connecticut, in 1963
Lives and works in Brooklyn, New York

Education

1989 M.F.A., Indiana University, Bloomington, Indiana
1989 Skowhegan School of Painting and Sculpture, Skowhegan, Maine
1985 B.F.A., State University of New York, New Paltz, New York
1980 Philadelphia College of Art, Philadelphia, Pennsylvania

Solo Exhibitions

2004
Contrails and Clusters, Pierogi, Brooklyn, New York, January 2–February 9
Lee Boroson: Inbetween, Genovese/Sullivan Gallery, Boston, Massachusetts,
 January 9–February 3
Outpost, Reynolds Gallery, Richmond, Virginia, May 7–August 20

2003
View From Here, Artspace, New Haven, Connecticut, July 18–September 20

2002
Lake Effect, Hallwalls Contemporary Art Center, Buffalo, New York,
 April 6–May 10

2000
Bubble Balcony, Mazer Theater, The Educational Alliance Art School, New York,
 December 5, 2001–March 1, 2002
Windowbox, H&R Block Artspace, Kansas City Art Institute, Kansas City,
 Missouri, November 10–December 20
Pleasure Grounds, Bemis Center for Contemporary Arts, Omaha, Nebraska,
 June 10–August 20

1999
Pleasure Grounds, Genovese/Sullivan Gallery, Boston, Massachusetts,
 April 17–May 8
Underpass, Whitney Museum of American Art at Phillip Morris (now called
 Whitney Museum of American Art at Altria), New York, October 29,
 1999–March 17, 2000

1997

Whitewater, Newhouse Center for Contemporary Art, Snug Harbor Cultural
 Center, Staten Island, New York, October 15, 1997–June 11, 1998
New Sculpture, Derek Eller Gallery, New York, September 4–October 5
Project Room, Bravin Post Lee Gallery, New York, April 25–May 24

1993

Sculpture, Hudson D. Walker Gallery, Fine Arts Work Center, Provincetown,
 Massachusetts, April

1992

New Work, Quint Krichman Projects, La Jolla, California, May 22–June 27

1991

Sculpture, Sushi Performance and Visual Art, San Diego, California,
 November 15–December 14

Installation view,
Lee Boroson: New Work, Quint
Krichman Projects, La Jolla,
California, 1992

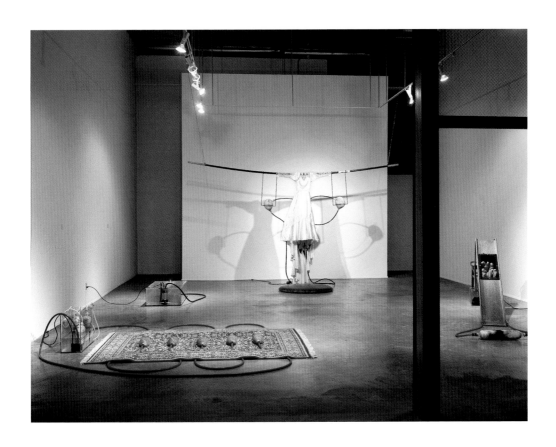

Selected Group Exhibitions

2005

New Tapestries, Sara Meltzer Gallery, New York

5 Projects/Wave Hill, Glyndor Gallery, Wave Hill, Bronx, New York, September 10–November 27

2004

About Sculpture, The Frances Young Tang Teaching Museum and Art Gallery at Skidmore College, Saratoga Springs, New York, June 26, 2004–January 2, 2005

2003

NextNext, Brooklyn Academy of Music, Brooklyn, New York, November 11–December 21

20/20 Vision, Museum of American Glass at Wheaton Village, Millville, New Jersey, June 1, 2003–January 4, 2004

2002

Artists to Artists: A Decade of the Space Program, Ace Gallery, New York, May 17–June 1

Thin Skin: The Fickle Nature of Bubbles, Spheres, and Inflatable Structures, AXA Gallery, New York, January 29–April 13; Traveled to Scottsdale Museum of Contemporary Art, Scottsdale, Arizona, May 25–September 15; Gemeentemuseum Helmond, Helmond, the Netherlands, October 5, 2002–January 5, 2003; McAllen International Museum, McAllen, Texas, January 25, 2003–March 30, 2003; Chicago Cultural Center, Chicago, Illinois, April 19, 2003–June 29, 2003; Edwin A. Ulrich Museum of Art, Wichita State University, Wichita, Kansas, July 20, 2003–September 28, 2003; Boise Art Museum, Boise, Idaho, March 6, 2004–May 16, 2004

2001

Brooklyn!, Palm Beach Institute of Contemporary Art, Palm Beach, Florida, September 9–November 25

2000

Soft Core, Joseph Helman Gallery, New York, December 9, 2000–January 20, 2001

Superduper New York, Pierogi, Brooklyn, New York, February

Showroom, Rensselaer County Council for the Arts (now called The Arts Center of the Capital Region), Troy, New York, January 29–April 8

1999

Men Who Sew, Elsa Mott Ives Gallery, YWCA, New York, November 2, 1999–January 2, 2000

Skin Tight, The Work Space, New York, November–December 4

Escape, DNA Gallery, Provincetown, Massachusetts, October 1–October 17

Another Place, Joseph Helman Gallery, New York, September 1–September 18

Neuberger Museum of Art 1999 Biennial Exhibition of Public Art, Neuberger Museum of Art, Purchase, New York, June 27–October 24

Zero-G: When Gravity Becomes Form, Whitney Museum of American Art at Champion, Stamford, Connecticut, June 4–August 8

Room With A View, Prince Street Gallery, New York, May 9–July 10

Lee Boroson / Heidi Schlatter, Momenta Art, Brooklyn, New York, February 7–March 8

1998

Seven Year Itch, Ambrosino Gallery, Miami, Florida, December 4, 1998–January 1999

After Modernism, Genovese/Sullivan Gallery, Boston, Massachusetts, October 10–November 4

Polter-Zeitgeist: A Survey of Mischievous Art, Cape Museum of Fine Art, Dennis, Massachusetts, October 4–November 8

Here: Artists' Interventions at the Aldrich Museum of Contemporary Art, Aldrich Contemporary Art Museum, Ridgefield, Connecticut, September 13, 1998–January 3, 1999

Fashioned, White Box Gallery, New York, September 10–October 31

Southern Exposure, Ambrosino Gallery, Miami, Florida, August 21–October 10

Crest Hardware Show, Crest Hardware, Brooklyn, New York, May–June

Humanoid, Genovese/Sullivan Gallery, Boston, Massachusetts, February 7–March 5; Traveled to Vedanta Gallery, Chicago, February 26, 1999–April 3, 1999; DiverseWorks, Houston, Texas, January 12, 2001–February 24, 2001; Frederieke Taylor Gallery, New York, December 6, 2001–January 12, 2002

1997

Pierogi Flat Files, Pierogi, Brooklyn, New York. Boroson's work has been shown in over a dozen Pierogi Flat Files traveling exhibitions since 1997. Selected venues include the Brooklyn Museum of Art, Brooklyn, New York, July 25, 1997–January 25, 1998; Weatherspoon Art Museum, Greensboro, North Carolina, November 16, 1997–January 18, 1998; Künstlerhaus, Vienna, Austria, August 28, 1998–September 28, 1998; Yerba Buena Center for the Arts, San Francisco, August 4, 2000–October 22, 2000; H&R Block Artspace, Kansas City Art Institute, Kansas City, Missouri, January 19, 2001–February 28, 2001; The Andy Warhol Museum, Pittsburgh, Pennsylvania, February 6, 2004–March 30, 2004

Emerging Sculptors 10, Sculpture Center, New York, January 7–January 28

1996

L'art du Plastique, Ecole nationale supérieure des Beaux-Arts, Paris, France, September 20–November 10

On the Map, Brooklyn Brewery, Brooklyn, New York, September 6–October 5

Horn of Fuente, 1994
Wood, PVC pipe, Styrofoam, plaster, corrugated fiberglass, rubber bladders, lycra, air, bull horns
Dimensions variable
Installation view, *InSITE 94,* Agua Caliente, Tijuana, Mexico, 1994

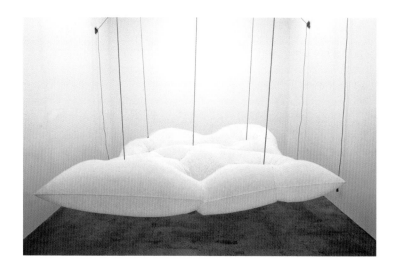

Hotwire, 1997
Nylon fabric, electric outlets,
cable, blower, air, electricity
10 x 12 x 20 feet
Installation view, Derek Eller
Gallery, New York

Delirious, Eighth Floor Gallery, New York, July
Crest Hardware Show, Crest Hardware, Brooklyn, New York, May 18–June 29;
 Traveled to SoHo Arts Festival, New York, September 7–October 7
Sauce '96, Sauce Gallery, Brooklyn, New York, February 11–March 10

1995
Sculpture Space: Celebrating Twenty Years, Munson-Williams-Proctor Arts
 Institute, Utica, New York, October 21–December 31
Crest Hardware Show, Brooklyn, New York, May–June 16

1994
InSITE 94, Installation Gallery, Agua Caliente, Tijuana, Mexico, September
 25–October 30
Long Island University Summer Sculpture Show, Long Island University
 Brooklyn Campus, Brooklyn, New York, June 15–October 31

1993
93 NY 50, Socrates Sculpture Park, Long Island City, New York, May 23–August 1

1992
Just Visiting, Rosa Esman Gallery, New York, December 5, 1992–January 2, 1993
Group Show, Hudson D. Walker Gallery, Fine Arts Work Center, Provincetown,
 Massachusetts, November
Streetsites '92, Tijuana River Estuarine Reserve, Imperial Beach, California,
 organized by Sushi Performance and Visual Art, March–April 11
The Fifth International Drawing Triennale, Museum of Architecture, Miejska
 Gallery, Wroclaw, Poland, March–April

1991
Three Dimensions, Mandeville Gallery, University of California San Diego,
 La Jolla, California, May 18–June 16

BIBLIOGRAPHY

Catalogues and Brochures

Armajani, Siah and Judy Collischan. *Neuberger Museum of Art 1999 Biennial Exhibition of Public Art*. Exhibition catalogue. Purchase, New York: Neuberger Museum of Art, 1999.

Berry, Ian. *Lee Boroson: Outer Limit*. Exhibition catalogue. Saratoga Springs: Tang Teaching Museum, 2005. Essay by Alva Noe.

Clausen, Barbara and Carin Kuoni. *Thin Skin: The Fickle Nature of Bubbles, Spheres, and Inflated Structures*. Exhibition catalogue. New York: Independent Curators International, 2002.

Fashioned. Exhibition catalogue. New York: White Box, 1998. Essay by Bill Arning.

Fifth International Triennial of Drawing. Exhibition catalogue. Wroclaw, Poland: Museum of Architecture, 1992.

Frankel, David, ed. *Artists to Artists: A Decade of the Space Program*. Exhibition catalogue. Colorado Springs, Colorado: The Marie Walsh Sharpe Art Foundation, 2002.

Frantz, Susanne K. and Gay LeCleire Taylor. *20/20 Vision*. Exhibition catalogue. Millville, New Jersey: Museum of American Glass at Wheaton Village, 2003.

Freedman, Matt. *Sculpture*. Exhibition catalogue. New York: SculptureCenter, in collaboration with Long Island University, Brooklyn, New York, 1994.

Herwig, Oliver and Axel Thallemer. *AIR/LUFT: Unity of Art and Science*. Stuttgart: Arnoldsche, 2005.

Humanoid. Exhibition brochure. Houston, Texas: DiverseWorks, 2001. Essay by Gregory Volk.

Markonish, Denise. *View From Here*. New Haven, Connecticut: Artspace, 2003.

Massier, John. *Lee Boroson: Lake Effect*. Exhibition brochure. Buffalo, New York: Hallwalls Contemporary Art Center, 2002.

Murray, Mary E. *Sculpture Space; Celebrating 20 Years*. Exhibition catalogue. Utica, New York: Munson-Williams-Proctor Institute, 1995.

Philbrick, Harry. *Here: Artists' Interventions at the Aldrich Museum of Contemporary Art [sic]*. Ridgefield, Connecticut: Aldrich Contemporary Art Museum, 1998.

Rush, Michael and Dominique Nahas. *Brooklyn!* Exhibition brochure. Lake Worth, Florida: Palm Beach Institute of Contemporary Art, 2001.

Singer, Debra. *Lee Boroson: Underpass*. Exhibition brochure. New York: Whitney Museum of American Art, 2000.

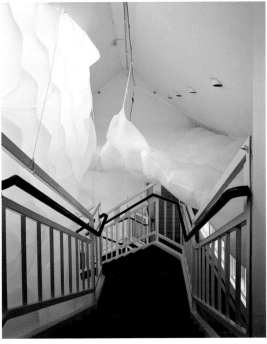

Cakewalk, 1998
Wood, painted steel, nylon fabric, blowers, rope, air
Dimensions variable
Installation view, *Here*, Adrich Contemporary Art Museum, Ridgefield, Connecticut

Smith, Raechell. *Lee Boroson: Windowbox*. Exhibition brochure. Kansas City, Missouri: H&R Block Artspace, Kansas City Art Institute, 2000.

Selected Articles and Reviews

Backlund, Nicholas. "Lee Boroson; Sculptor." *San Diego Daily Transcript* (20 September 1994).

Birke, Judy. "Spotlighted at Artspace, a cityscape with a view." *New Haven Register* (22 September 2003).

Blandford, Kristin. "Gender Allusion." *Surface*, no. 21 (January 2000): 42.

Camhi, Leslie. "Blow Up." *Village Voice* (13 February 2002).

Cotter, Holland. "Sculpture Under the Sky: Free, Daring and Soon Departed." *New York Times* (26 August 1994): C1.

Curcio, R. "'Softcore': Joseph Helman Gallery." *Sculpture* 20, no. 5 (June 2001): 73–74.

Dalton, Jennifer. "Fashioned." *Review Magazine* (15 September 1998).

Delblanco, Andrea. "Men With Needles and Some Points to Make." *New York Times* (7 November 1999): CY16.

Freedman, Matt. "Emerging Sculptors 10." *Review Magazine* (15 January 1997).

Goodman, Jonathan. "Lee Boroson: Whitney Museum of American Art at Philip Morris." *Sculpture* 19, no. 7 (September 2000): 64–65.

Hershenson, Roberta. "Sunlight and Shade Infuse Sculptures." *New York Times* (11 July 1999) sec. 14WC: 19.

Hill, Shawn. "Loving and Delving." *Bay Windows* (February 1998).

Huntington, Richard. "Cloudy Thinking." *Buffalo News* (3 May 2002): G18.

Johnson, Ken. "Another Place." *New York Times* (10 September 1999): sec. E: 36.

—. "Fred Tomaselli and Lee Boroson." *New York Times* (24 December 1999): sec. E: 52.

—. "Skintight." *New York Times* (26 November 1999): sec. E: 42.

Kimmelman, Michael. "'93 New York 50' at Socrates Sculpture Park." *New York Times* (6 August 1993): C30.

Levin, Kim. "Lee Boroson + Fred Tomaselli." *Village Voice* (5 January 2000).

MacMillan, Kyle. "Bemis Center Installations a Fun, Sensuous Experience" *Omaha World Herald* (18 June 2000): 13.

Mante, Alexis. "Students create 'insider' artwork." *New Haven Register* (15 July 2003).

McNally, Molly. "Lily Pads and Neon Chromosomes." *The Reader* (2 August 2000).

McQuaid, Cate. "Lily pads; miniature myths; the Big Dig on canvas." *Boston Globe* (29 April 1999): E3.

—. "Sculpture, Photos capture things in flux." *Boston Globe* (16 January 2004): D16.

Richard, Frances. "Underpass at Whitney Philip Morris," *Artforum* 38, no. 10 (Summer 2000): 185.

Shales, Ezra. "Emerging Sculptors 10." *Review Magazine* (15 January 1997).

Thorson, Alice. "'Windowbox' on the world." *Kansas City Star* (10 December 2000).

Toivanen, Kati. "On Topic: Interiors, Balloons, and Marcel Duchamp." *Review Magazine* (December 2000).

Unger, Miles. "Lee Boroson: Pleasure Grounds." *Art New England* 20, no. 5 (August/September 1999).

Viveros-Faune, Christian. "Lee Boroson." *Contemporary*, no. 64 (2004): 26–29.

Waterman, Jill. "Lee Boroson's Fabricated Garden." *artsMEDIA* (December 1999).

Wisniewski, Adam. "Sew what?; Men pick up the needle but avoid getting into knots about gender." *Time Out New York*, no. 219 (2 December 1999).

Worth, Alexi. "Star Track: The Next Generation—Lee Boroson." *artNEWS* 97, no. 5 (May 1998): 159.

Pratt's Castle, Richmond, Virginia, 2004
34 x 22 x 30"
Glass, silicone, lightbox, Duratrans (Image courtesy of the Library of Virginia)
Collection of Beverly Reynolds, Richmond, Virginia

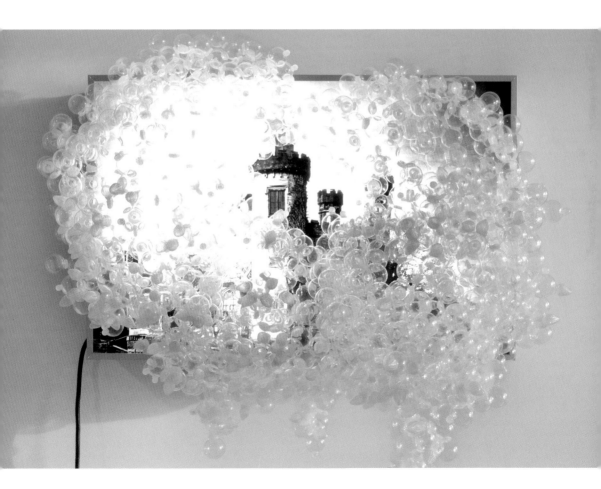

ACKNOWLEDGEMENTS

The Opener series at the Tang Museum allows us many unique opportunities to work with artists in all stages of their practice. *Lee Boroson: Outer Limit* showed off the best of how that collaboration between an artist and the museum can work. Often an artist's project is imagined bigger than their studio or a commercial gallery can accommodate. When planning this exhibition with Lee, we realized that we could help provide the support and space needed to realize several new ideas he had been experimenting with over the past few years. It was our great pleasure to see these projects come to life and view the spaces of the museum as never before.

The funders of the Opener series deserve special thanks for their continued support of these projects. Thanks to the Overbrook Foundation, The New York State Council on the Arts, the Laurie Tisch Sussman Foundation, and the Friends of the Tang.

The entire Tang staff worked together to create this project. Special thanks are due to Ginger Ertz, Lori Geraghty, Elizabeth Karp, Susi Kerr, Gayle King, Ginny Kollak, Patrick O'Rourke, and John Weber. Our installation crew deserves the greatest thanks for their long hours and creative solutions at all stages. Thanks to Nicholas Warner, Chris Kobuskie, Torrance Fish, Abraham Ferraro, Sam Coe, and Jay Tiernan.

The catalogue is an important record of Lee's work to date. It has been created by our wonderful designer Bethany Johns and features many new photographs by Arthur Evans. Alva Noë deserves special thanks for his essay, which brings a new set of questions to the artwork. I would like to thank Amy Podmore, Frank Jackson and Derek Eller for introducing me to Lee's great work many years ago. My greatest appreciation goes to Lee, whose spirit of collaboration is something I will keep with me as a model for future projects. His exhibition pushed us to realize our potential as a museum and kept us in sweet awe each time we walked through the space.

— IAN BERRY

There are many individuals and organizations I wish to acknowledge for all that they've done to help make this exhibition possible. First, I'd like to thank Ian Berry for believing in my mission and providing support and encouragement over the two plus years that it took to assemble these projects. He's an extraordinary curator and interviewer, and truly moves mountains. My brother, Todd Boroson, helped me to navigate a world of data that I barely grasp, and acted as my patient and capable guide throughout the development and production of *Star Swarm*; I am extremely grateful for his willingness to collaborate. I offer kudos and huge amounts of gratitude to Alva Noë for his brilliance and commitment of time to write such a thought-provoking and eloquent essay. Thank you to Meridith Pingree and Kai Vierstra for their hard work in the studio, endless hours of sanding, trimming, painting, and tweaking. I cannot give high enough praise to Nick Warner, Chris Kobuskie, and the installation crew at the Tang Museum for their careful, skillful, and energetic support in getting all seven incredibly challenging projects installed beautifully in the space. Special thanks to Torrance Fish for his commitment and inspirational drive to get everything just right. Warm thanks to Curtis Breedlove at P/Kaufmann, New York, for his wise support in selecting and acquiring the textiles. Beverly Reynolds at Reynolds Gallery gave her support during the development of the ideas that were eventually realized in *Outer Limit*; I truly appreciate her enthusiasm.

I would like to recognize Rich Kron, Mark SubbaRao, Alex Szalay, and Jim Gray at Sloan Digital Sky Survey for their support and correspondence in the development of my *Celestial Incorporation Project*, and Bud Saggal at Precision Laser, Providence, and Joseph Akkaoui at Tanury Industries, Lincoln, Rhode Island for their assistance in the construction of *Lucky Storm* and for letting me test the limits of their technology. Rhode Island School of Design Part Time Union, also in Providence, provided financial support towards the development of the *Celestial Incorporation Project*. Thanks to Recycling for Rhode Island Education, Providence, for recognizing that little glass spheres might be a good material for artists.

I gratefully acknowledge Camellia Genovese and David Sullivan at Genovese Sullivan Gallery, Boston, for their belief and support of my artwork over the years and their brilliant fundraising in the original production of *Pleasure Grounds*. And especially, I offer my loving gratitude to Kirsten Hassenfeld for her patience, understanding, support, and suggestions as I developed these projects.

— LEE BOROSON

This catalogue accompanies the exhibition

OPENER **8**

LEE BOROSON: *OUTER LIMIT*

The Frances Young Tang Teaching Museum and Art Gallery at Skidmore College,
Saratoga Springs, New York
February 5–June 5, 2005

The Frances Young Tang Teaching Museum and Art Gallery
Skidmore College
815 North Broadway
Saratoga Springs, New York 12866
T 518 580 8080
F 518 580 5069
www.skidmore.edu/tang

State of the Arts
NYSCA

This exhibition and publication are made possible in part with public funds from
the New York State Council on the Arts, a state agency, The Laurie Tisch Sussman
Foundation, The Overbrook Foundation, and the Friends of The Tang.

Front cover:
Lucky Storm (2), 2004
Nylon, monofilament, stainless steel, hardware, blower, gold, air
Dimensions variable
Installation view, Tang Museum, Skidmore College, 2005

Page 1:
Hilliard Homes, designed by Bertrand Goldberg & Associates, 1966.
Photograph by Lee Boroson

Photography:
All photographs by Lee Boroson except the following:
cover, p. 36, 37, 40–41, 42, 50–51: Arthur Evans
p. 14: Chris Greene
p. 28, 29, 32–33: George Hirose
p. 30, 31: H&R Block Artspace
p. 34, 35: Jessica Kourkounis
p. 52, 53: Patrick O'Rourke
p. 55: Roy Porello
p. 57: Philipp Scholz Rittermann
p. 59: Liz Deschenes

Designed by Bethany Johns
Printed in Germany by Cantz